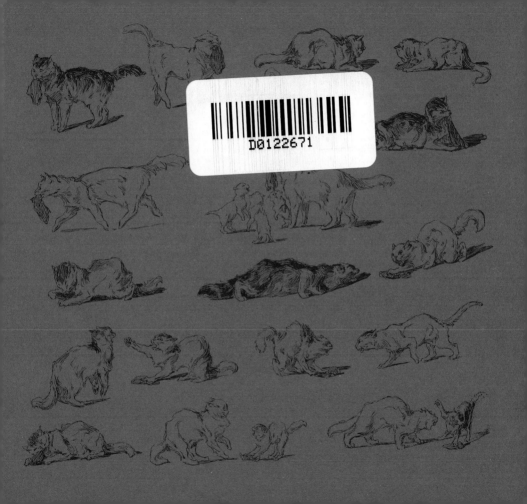

Catnip

Artful Felines from The Metropolitan Museum of Art

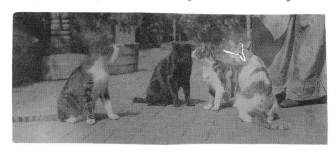

CHRONICLE BOOKS
SAN FRANCISCO

THE METROPOLITAN MUSEUM OF ART • New York

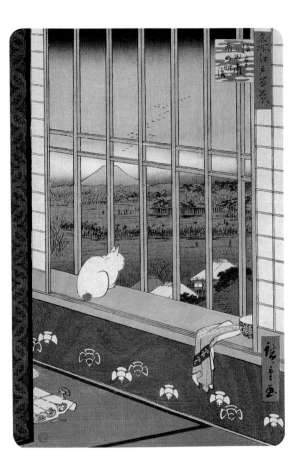

Anyone who has observed a cat under the influence of catnip knows that this seemingly innocuous herb can drive even a sedate, standoffish, or somnolent cat to all kinds of indecorous antics. The tabby that usually regards its surroundings with aloof indifference is suddenly rolling on the floor and caterwauling to the heavens. The elderly puss is roused from its daily twenty-two hour nap to return to the playful pouncing of kittenhood.

Curiously, living with cats seems to have a similarly stimulating effect on humans, causing otherwise dignified personages—including Cardinal Richelieu and Pope Leo XII—to become doting sentimentalists. Philosophers and poets have turned their talents toward eulogizing their feline companions, and humorists have attacked the subject with wits as sharp as their pets' claws. Artists, too, have been smitten with kittens, seduced into attempting their portraits by their sleek shapes and elegant poses, glowing eyes and infinitely suggestive expressions, even though, as the ailurophile Théophile Gautier said, "Painting cats is a question of genius."

Still, "Time spent with cats is never wasted," wrote Colette, who indeed spent a great deal of hers with them. And surely she is right, if the hours thus occupied lead artists and writers to devise enchanting pictures and sprightly sayings like those included in this book, itself a tidbit of catnip for cat people.

—Carolyn Vaughan

Asakusa Rice Fields and Torinomachi Festival. Utagawa Hiroshige, Japanese, 1797–1858

A kitten is infinitely more amusing than half the people one is obliged to live with in the world.

Lady Morgan (Sydney Owenson), Irish, 1776–1859

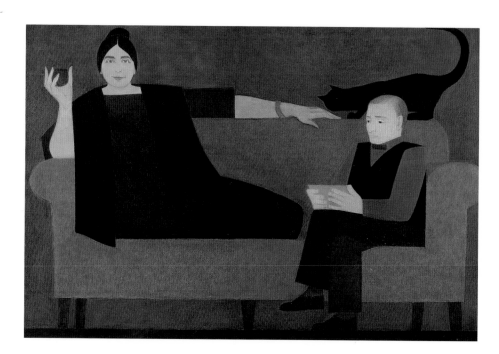

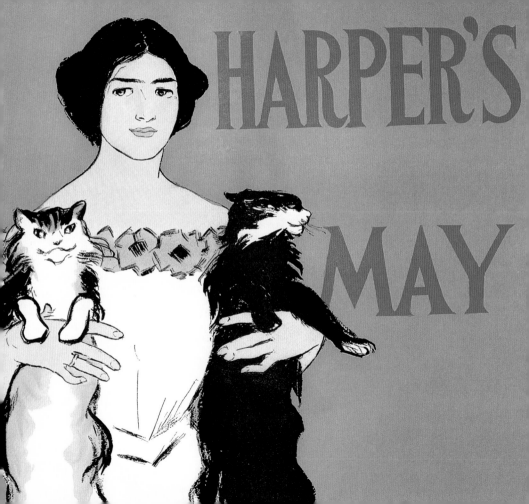

If you want to be a psychological novelist and write about human beings, the best thing you can do is to keep a pair of cats.

If man could be crossed with a cat it would improve man, but it would deteriorate the cat.

Mark Twain, American, 1835–1910

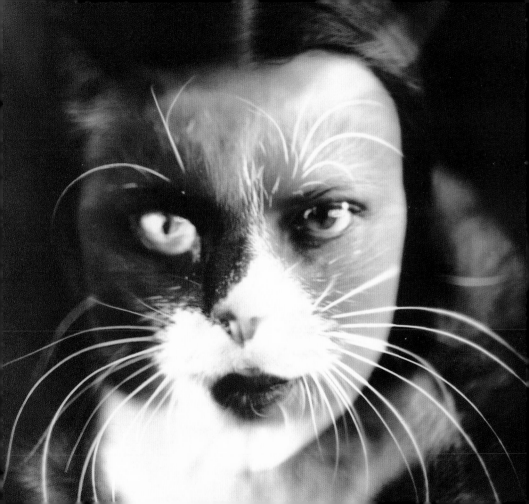

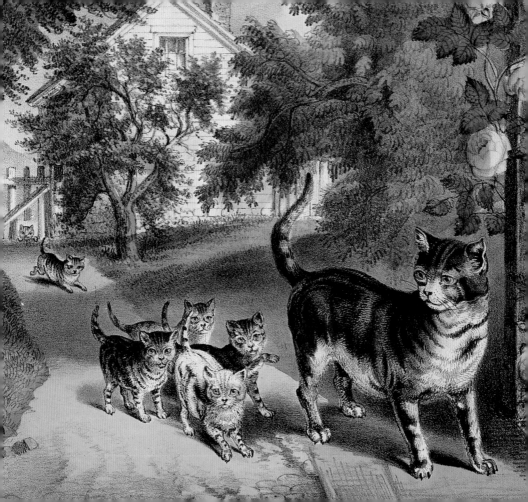

No matter how much the cats fight, there always seem to be plenty of kittens.

Abraham Lincoln, American, 1809–1865

Books and cats and fair-haired little girls make the best furnishing for a room.

French proverb

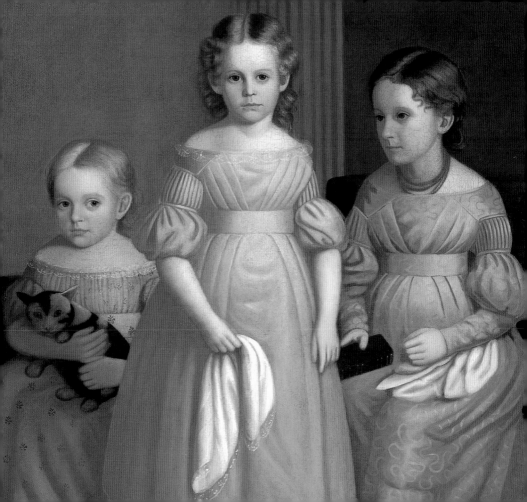

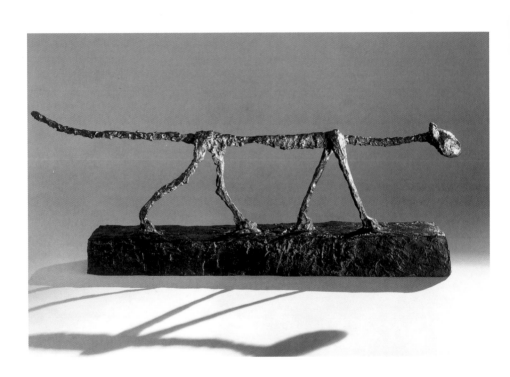

Cats sleep fat and walk thin.
Cats, when they sleep, slump;
When they wake, stretch and begin
Over, pulling their ribs in.
Cats walk thin.

Rosalie Moore, American, 1910–2001

Cat. Alberto Giacometti, Swiss, 1901–1966

Cats, as a class, have never completely got over the snootiness caused by the fact that in ancient Egypt they were worshiped as gods.

P. G. Wodehouse, English, 1881–1975

Coffin for a Cat. Egyptian, Ptolemaic period (305–30 B.C.)

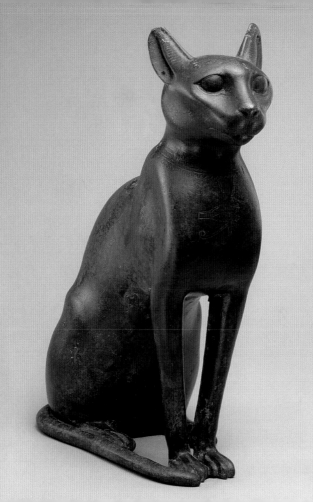

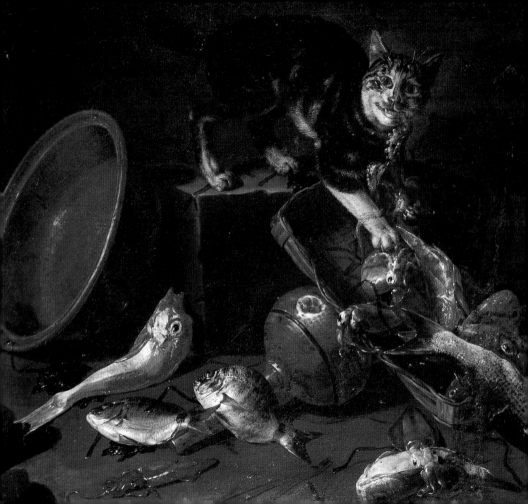

When food mysteriously goes,
The chances are that Pussy knows
More than she leads you to suppose.

Anonymous

A Cat Stealing Fish (detail). Giuseppe Recco, Italian (Neapolitan), 1634–1695

I guess a cat is sort of like a poem.
A cat is relatively short. A cat is only
subtly demonstrative. To be sure, you
can curl up with a good cat, but that
doesn't mean you *understand* the cat.
A dog is like Dickens.

Roy Blount, Jr., American, b. 1941

Harper's Christmas 1894 (detail). Edward Penfield, American, 1866–1925

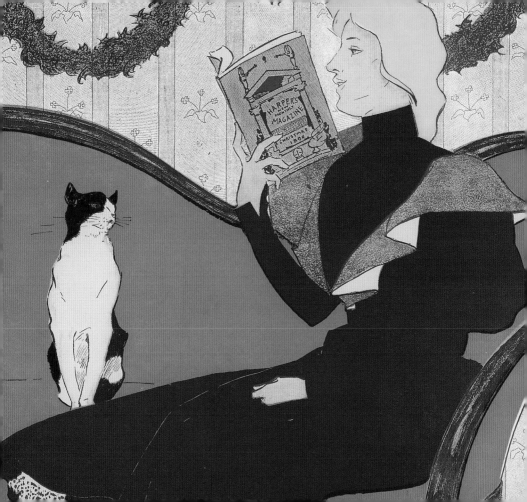

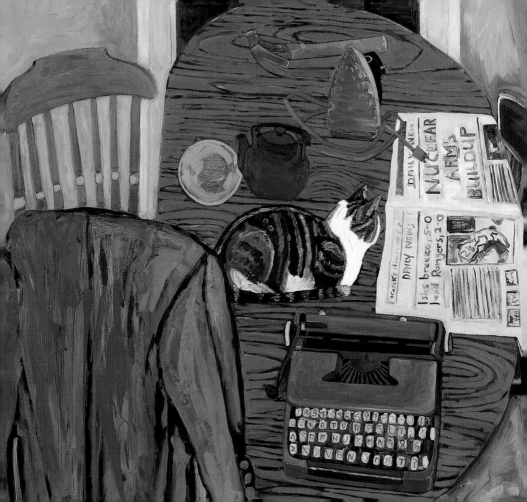

One reason cats are happier than people is that they have no newspapers.

Gwendolyn Brooks, American, 1917–2000

Daily News (detail). Dona Nelson, American, b. 1952

The cat is cryptic, and close to strange things which men cannot see.

H. P. Lovecraft, American, 1890–1937

Joseph Interpreting the Dreams of His Fellow Prisoners. Master of the Story of Joseph, Netherlandish, about 1500

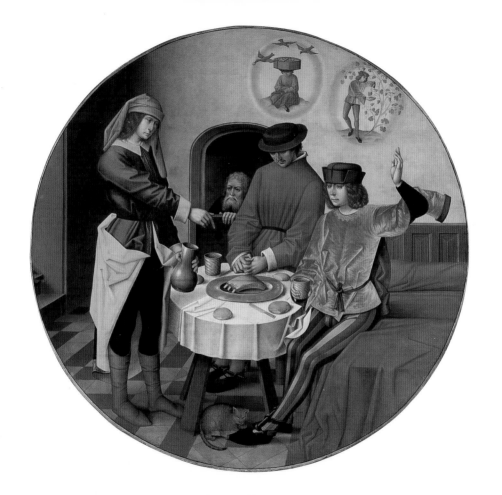

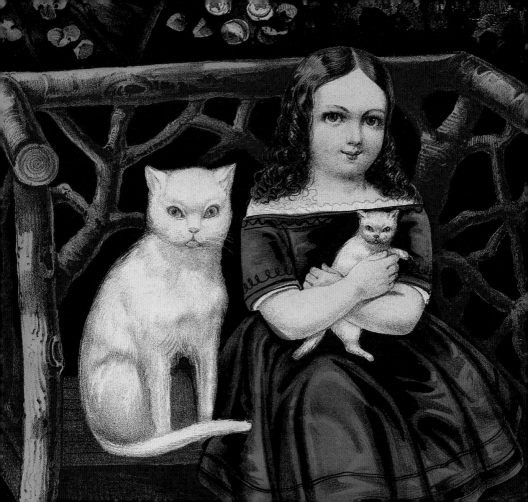

Gather kittens while you may,
 Time brings only sorrow;
And the kittens of today
 Will be old cats tomorrow.

Oliver Herford, American, 1863–1935

She sights a Bird—she chuckles—
She flattens—then she crawls—
She runs without the look of feet—
Her eyes increase to Balls—

Emily Dickinson, American, 1830–1886

Don Manuel Osorio de Zuñiga (1784–1792) (detail). Francisco de Goya y Lucientes, Spanish, 1746–1828

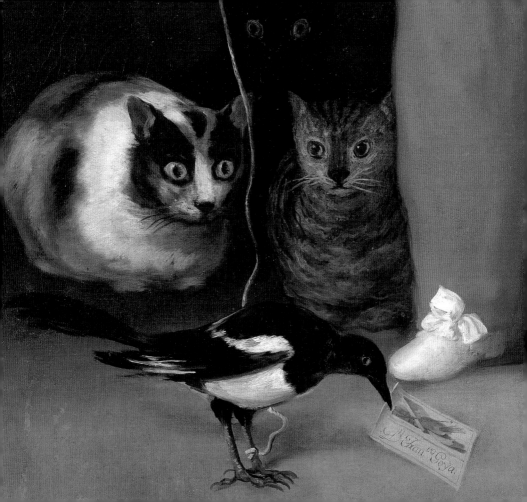

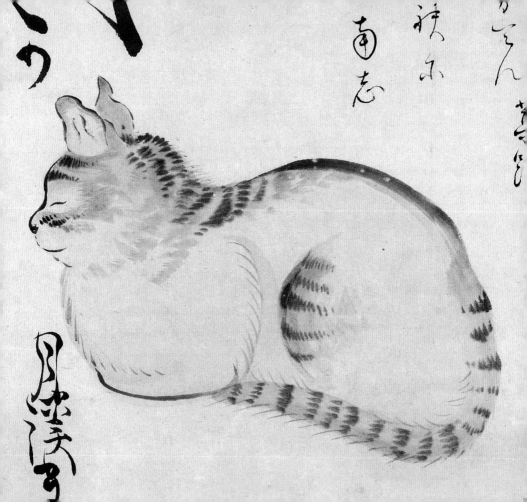

The ideal of calm exists
in a sitting cat.

Jules Renard, French, 1864–1910

Seated Cat (detail). Matsumura Goshun, Japanese, 1752–1811

I was only four years old when I was first in Paris and talked french there and was photographed there and went to school there, and ate soup for early breakfast and had leg of mutton and spinach for lunch, I always liked spinach, and a black cat jumped on my mother's back. That was more exciting than peaceful. I do not mind cats but I do not like them to jump on my back.

Gertrude Stein, American, 1874–1946

Amelia Van Buren (detail). Thomas Eakins, American, 1844–1916

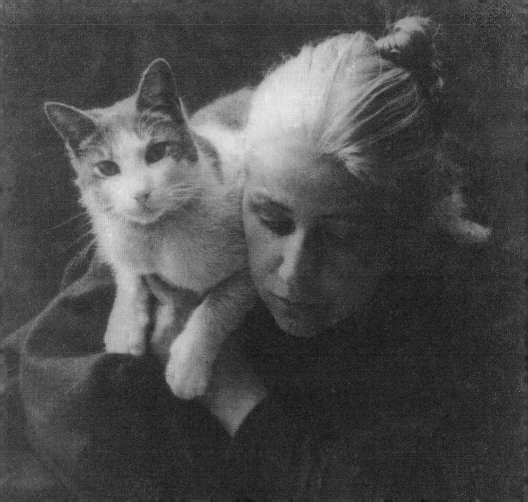

liberati seruiamus illi

In sanctitate et iusti
tia coram ipso omnibz di
ebz nris

Et tu puer propheta al
tissimi uocaberis preibis
enim ante faciem domi
ni parare uias eius.

Ad dandam scienciam

When I play with my cat, who knows whether she is not amusing herself with me more than I with her?

Michel de Montaigne, French, 1533–1592

Page from "The Hours of Jeanne D'Evreux" (detail). Jean Pucelle, French, 14th century

It is a crafty, subtle, watchful Creature, very loving and familiar with Mankind; but the mortal Enemy of the Rat, Mouse, and every sort of Bird, which it seizes on as its Prey.

William Salmon, English, 1644–1713

Cat and Spider (detail). Tōkō (Ōide Makoto), Japanese, 1841–1905

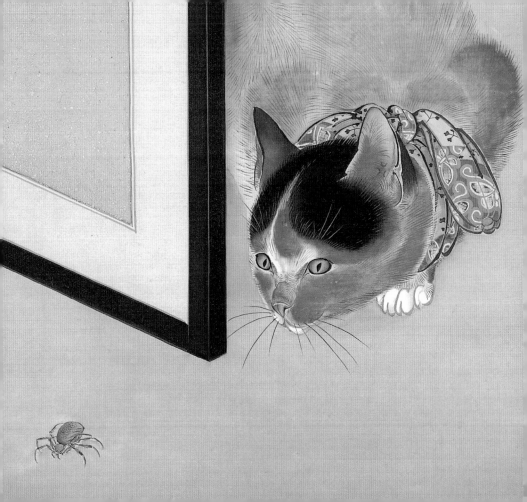

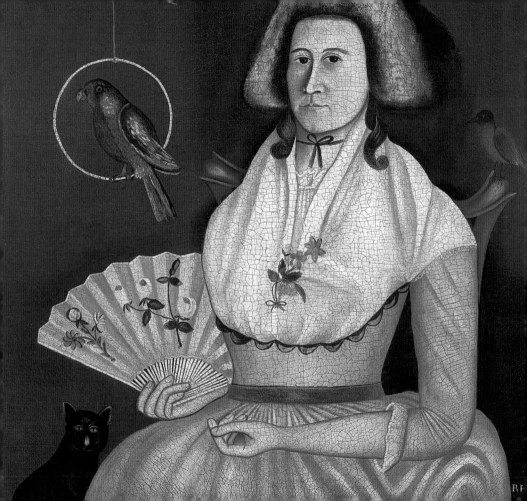

I never married because there was no need. I have three pets at home which answer the same purpose as a husband. I have a dog which growls every morning, a parrot which swears all afternoon, and a cat that comes home late at night.

Marie Corelli, English, 1855–1924

A kitten is the joy of a household. All day long this incomparable actor plays his little comedy, and those who search for perpetual motion can do no better than watch his antics.

Champfleury, French, 1821–1889

My Little White Kitties into Mischief (detail). Currier and Ives, publishers, American, active 1857–1907

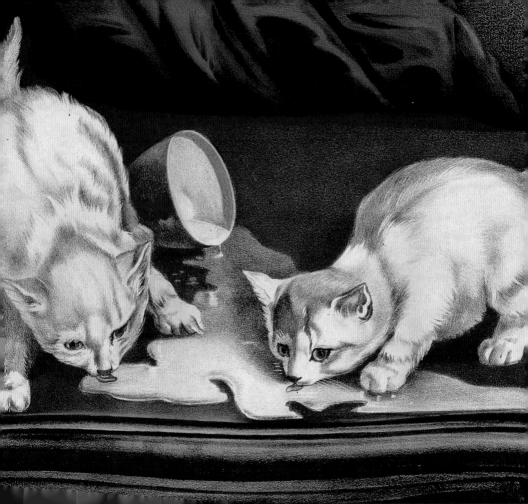

When the tea is brought at five o' clock,
And all the neat curtains are drawn with care,
The little black cat with bright green eyes
Is suddenly purring there.

Harold Monro, Scottish, 1879–1932

Cats are rather delicate creatures and they are subject to a good many different ailments, but I never heard of one who suffered from insomnia.

Joseph Wood Krutch, American, 1893–1970

Cat. Tsugouhara Foujita, French (b. Japan), 1886–1968

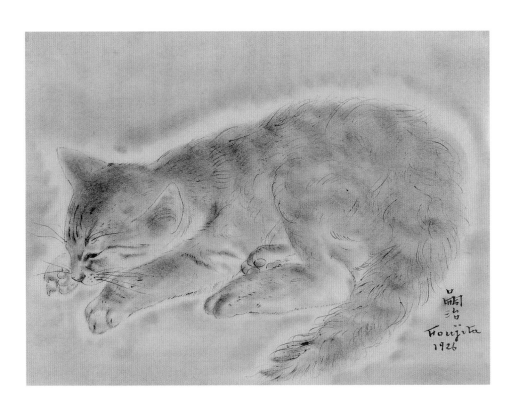

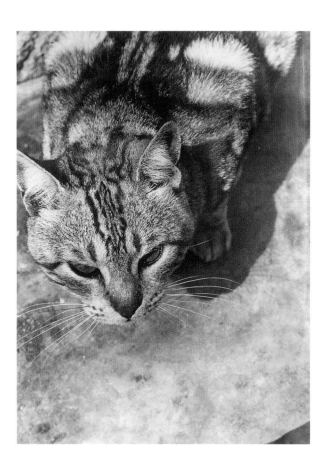

Ah! Cats are a mysterious kind of folk. There is more passing in their minds than we are aware of.

Sir Walter Scott, Scottish, 1771–1832

This male cat is the sun-god Re himself. . . .

The Egyptian Book of the Dead

The Sun God Re, Shown as a Cat, Killing the Serpent Apophis (detail). Egyptian, Dynasty 19 (1295–1186 B.C.)

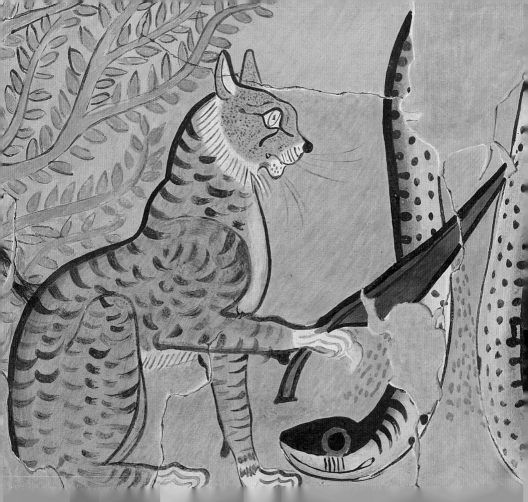

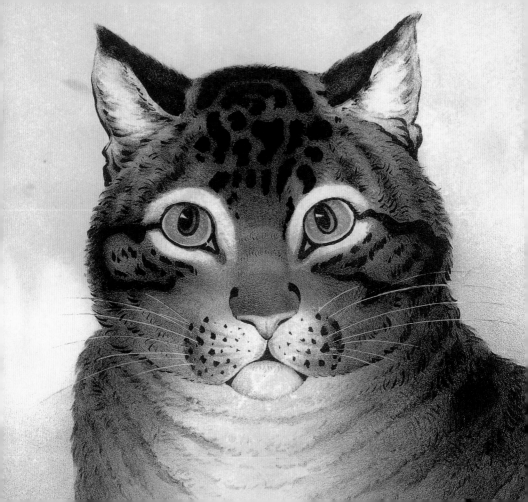

My cat does not talk as respectfully to me as I do to her.

Colette, French, 1873–1954

Like a graceful vase, a cat, even when motionless, seems to flow.

George F. Will, American, b. 1941

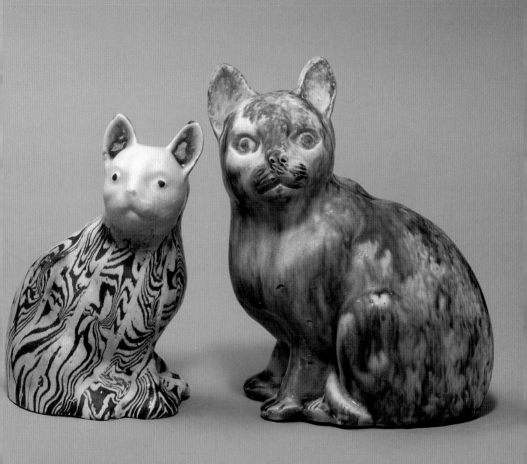

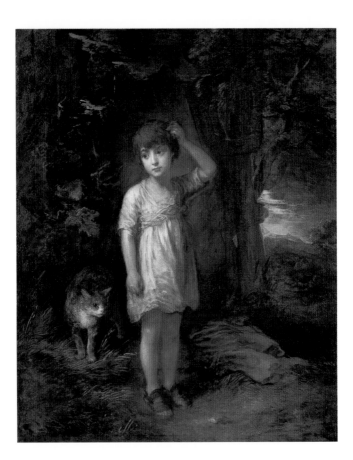

When a cat adopts you there is nothing to be done about it except to put up with it until the wind changes.

T. S. Eliot, English (b. United States), 1888–1965

A Boy with a Cat—Morning. Thomas Gainsborough, English, 1727–1788

I love cats because I enjoy my home; and little by little, they become its visible soul.

Jean Cocteau, French, 1889–1963

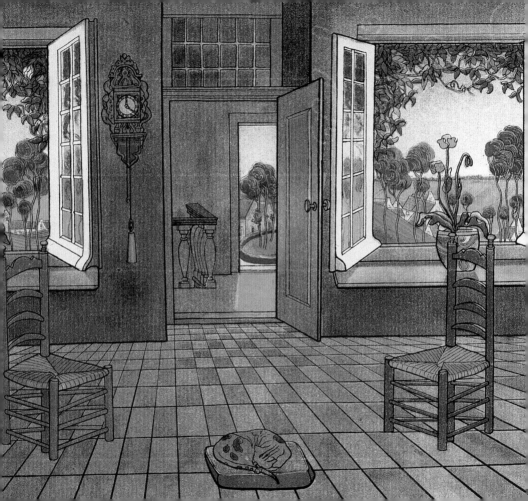

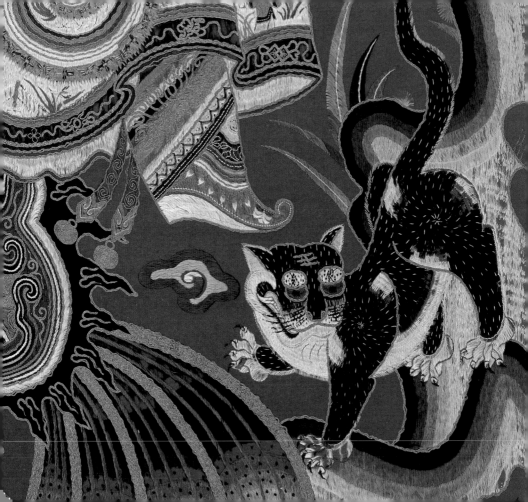

Dawn follows Dawn and Nights grow old and all
 the while this curious cat
Lies crouching on the Chinese mat with eyes of
 satin rimmed with gold.

Oscar Wilde, Irish, 1854–1900

Theater Curtain (detail). Chinese, Qing dynasty (1644–1911)

It is perfectly possible (a fact which I have proved scores of times myself) to work not only with a cat in the room, but with a cat on one's shoulder or in one's lap. In a drafty room, indeed, the cat makes a superior kind of paperweight!

Carl Van Vechten, American, 1880–1964

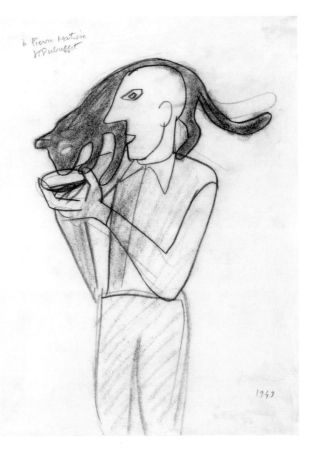

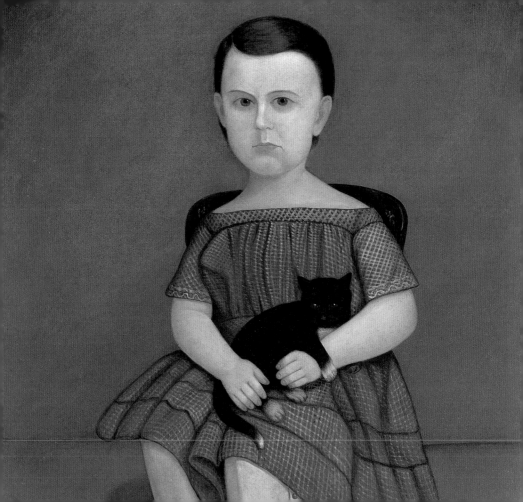

If a dog jumps into your lap it is because he is fond of you; but if a cat does the same thing it is because your lap is warmer.

Alfred North Whitehead, English, 1861–1947

Martha Bartlett with Kitten (detail). American, 1875–1900

When the cat winketh, little knows
the mouse what the cat thinketh.

English proverb

Cat and Mouse (detail). Kawanabe Kyōsai, Japanese, 1831–1889

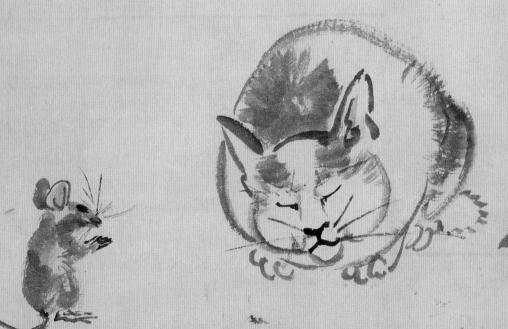

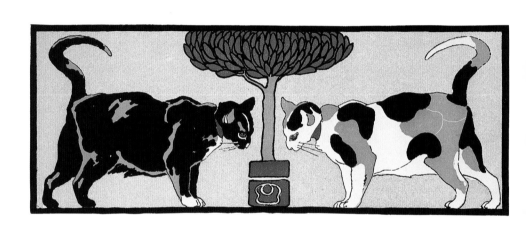

One cat just leads to another.

Ernest Hemingway, American, 1899–1961

I want to create a cat like the real cats I see crossing the street, not like those you see in houses. They have nothing in common. The cat of the street has bristling fur. It runs like a fiend, and if it looks at you, you think it is going to jump in your face.

Pablo Picasso, Spanish, 1881–1973

Tomcat's Turf. Paul Klee, German (b. Switzerland), 1879–1940

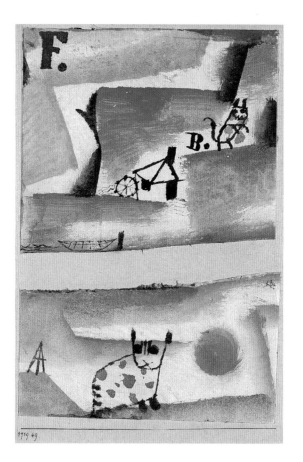

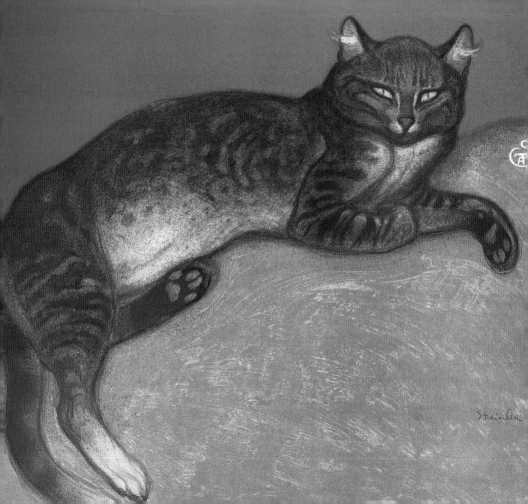

The cat is a dilettante in fur.

Théophile Gautier, French, 1811–1872

The smallest feline is a masterpiece.

Leonardo da Vinci, Italian (Florentine), 1452–1519

Pet Cat. Kawabata Gyokusho, Japanese, 1842–1913

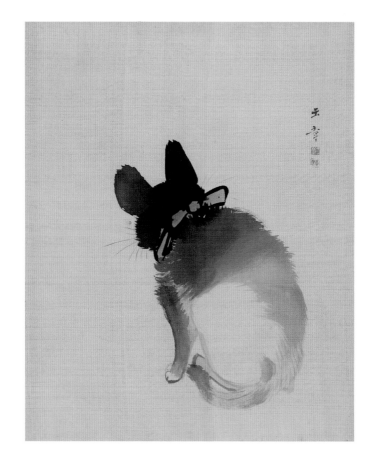

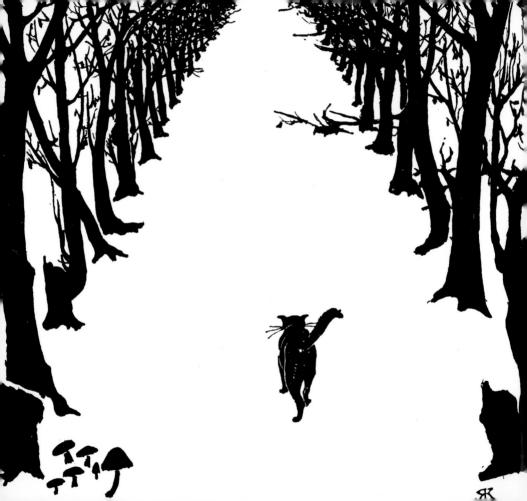

I am not a friend, and I am not a servant. I am the Cat who walks by himself. . . .

Rudyard Kipling, English, 1865–1936

Credits

All of the works reproduced in this book are from the collections of The Metropolitan Museum of Art.

FRONT COVER
The Favorite Cat (detail)
Nathaniel Currier, publisher, American, 1813–1888
Hand-colored lithograph, 12⅛ x 8¾ in., ca. 1838–56
Bequest of Adele S. Colgate, 1962
62.550.159

ENDPAPERS
Miaulements (detail)
Théophile-Alexandre Steinlen, French, 1859–1923
Photorelief etchings from *Des Chats: Images Sans Paroles* (*Cats: Pictures Without Words*), 1898
Gift of Mrs. Edward C. Moën, 1961 61.687.12

TITLE PAGE
[*Four Cats*]
Thomas Eakins, American, 1844–1916
Platinum print, 2⅞ x 5⅜ in., ca. 1895
Gift of Joan and Martin E. Messinger, 1985 1985.1027.17

INTRODUCTION
Asakusa Rice Fields and Torinomachi Festival
Utagawa Hiroshige, Japanese, 1797–1858
Polychrome woodblock print, from the series *One Hundred Famous Views of Edo*, 13¼₆ x 8¹¹⁄₁₆ in., 1857
Rogers Fund, 1914 JP 60

Kiesler and Wife
Will Barnet, American, b. 1911
Oil on canvas, 48 x 71½ in., 1963–65
Purchase, Roy R. and Marie S. Neuberger Foundation Inc. Gift and George A. Hearn Fund, 1966 66.66

Harper's May (detail)
Edward Penfield, American, 1866–1925
Color lithograph, 17¾ x 11⅞ in., 1896
Leonard A. Lauder Collection of American Posters, Gift of Leonard A. Lauder, 1984 1984.1202.88

Cat and I (detail)
Wanda Wulz, Italian, 1903–1984
Gelatin silver print, 11⁹⁄₁₆ x 9⅛ in., 1932
Ford Motor Company Collection, Gift of Ford Motor Company and John C. Waddell, 1987 1987.1100.123

Pussy's Return (detail)
Currier and Ives, publishers, American, active 1857–1907
Hand-colored lithograph, 8½ x 12½ in.
Bequest of Adele S. Colgate, 1962
63.550.314

The Alling Children (detail)
Oliver Tarbell Eddy, American, 1799–1868
Oil on canvas, 47⅛ x 62⅞ in., ca. 1839
Gift of Edgar William and Bernice Chrysler Garbisch, 1966
66.242.21

Cat
Alberto Giacometti, Swiss, 1901–1966
Bronze, H. 11 in., 1954
Jacques and Natasha Gelman Collection, 1998 1999.363.24

Coffin for a Cat
Egyptian, Ptolemaic period (305–30 B.C.)
Bronze, H. 11 in.
Harris Brisbane Dick Fund, 1956
56.16.1

A Cat Stealing Fish (detail)
Giuseppe Recco, Italian
(Neapolitan), 1634–1695
Oil on canvas, 38 x 50½ in.
Purchase, 1871 71.17

Harper's Christmas 1894 (detail)
Edward Penfield, American,
1860–1925
Commercial lithograph,
18¼ x 13 in., 1894
Gift of David Silve, 1936
36.23.26

Daily News (detail)
Dona Nelson, American, b. 1952
Oil on canvas, 84 x 60 in., 1983
Purchase, Emma P. Ziprik Memorial
Fund Gift, in memory of Fred and
Emma P. Ziprik, 1984 1984.266

*Joseph Interpreting the Dreams of His
Fellow Prisoners*
Master of the Story of Joseph,
Netherlandish, about 1500
Oil on wood, Diam. 61½ in.
Harris Brisbane Dick Fund, 1953
53.168

The Little Pets (detail)
Currier and Ives, publishers,
American, active 1857–1907
Hand-colored lithograph, 12 x 9 in.
Bequest of Adele S. Colgate, 1962
63.550.333

*Don Manuel Osorio de Zuñiga
(1784–1792)* (detail)
Francisco de Goya y Lucientes,
Spanish, 1746–1828
Oil on canvas, 50 x 40 in.
The Jules Bache Collection, 1949
49.7.41

Seated Cat (detail)
Matsumura Goshun, Japanese,
1752–1811
Hanging scroll; ink and color on
paper, 39⅛ x 11⅜ in.
Rogers Fund, 1971 1971.190

Amelia Van Buren (detail)
Thomas Eakins, American,
1844–1916
Platinum print, 8¼ x 6⅜ in., ca. 1890
David Hunter McAlpin Fund, 1943
43.87.16

*Page from "The Hours of Jeanne
D'Evreux"* (detail)
Jean Pucelle, French, 14th century
Grisaille and color on vellum,
3½ x 2½ in., 1325–28
The Cloisters Collection, 1954
54.1.2 folio 51r

Cat and Spider (detail)
Tōkō (Ōide Makoto), Japanese,
1841–1905
Ink and color on silk, 14¾ x 4⅜ in.
Charles Stewart Smith Collection, Gift
of Mrs. Charles Stewart Smith,
Charles Stewart Smith Jr., and Howard
Caswell Smith, in memory of Charles
Stewart Smith, 1914 14.76.61.73

*Lady with Her Pets (Molly Wales
Fobes)* (detail)
Rufus Hathaway, American,
1770–1822
Oil on canvas, 34¼ x 32 in., 1790
Gift of Edgar William and Bernice
Chrysler Garbisch, 1963 63.201.1

My Little White Kitties into Mischief
(detail)
Currier and Ives, publishers,
American, active 1857–1907
Hand-colored lithograph, 8¼ x 12½ in.
Bequest of Adele S. Colgate, 1962
63.550.479

Compagnie Française des Chocolats et des Thés
Théophile-Alexandre Steinlen,
French, 1859–1923
Color lithograph, 40 x 30 in., 1899
Gift of Bessie Potter Vonnoh, 1941
41.12.19

Cat
Tsugouhara Foujita, French (b.
Japan), 1886–1968
Pen, brush, and ink on paper,
6¼ x 8⅝ in., 1926
Bequest of Miss Adelaide Milton de
Groot (1876–1967), 1967
67.187.7

[*Cat Seen from Above*]
László Moholy-Nagy, American
(b. Hungary), 1895–1946
Gelatin silver print, 9⅞₆ x 6⅞ in.,
ca. 1926
Gift of Emanuel Gerard, 1985
1985.1150.4

*The Sun God Re, Shown as a Cat, Killing
the Serpent Apophis* (detail)
Egyptian, Dynasty 19
(1295–1186 B.C.)
Copy of a wall painting in the tomb
of Sennedjem, Thebes
Rogers Fund, 1930 30.4.1

The Favorite Cat (detail)
Nathaniel Currier, publisher,
American, 1813–1888
Hand-colored lithograph,
12⅛ x 8¾ in., ca. 1838–56
Bequest of Adele S. Colgate, 1962
62.550.159

Two Cats
English (Staffordshire), mid-18th
century
Earthenware
The Helen and Carleton Macy
Collection, Gift of Carleton Macy,
1934, and Gift of Mrs. Russell S.
Carter, 1944 34.165.20;
44.39.45

A Boy with a Cat—Morning
Thomas Gainsborough, English,
1727–1788
Oil on canvas, 59¼ x 47½ in., 1787
Marquand Collection, Gift of Henry
G. Marquand, 1889 89.15.8

Summer (detail)
Franz M. Melchers, Belgian,
1868–1944
Hand-tinted lithograph illustration
from *L'An* (poems by Thomas
Braun), published in Brussels by E.
Lyon-Claesen, 1897; 10 x 10 in.
The Elisha Whittelsey Collection,
The Elisha Whittelsey Fund, 1967
67.763.1

Theater Curtain (detail)
Chinese, Qing dynasty (1644–1911)
Wool flannel, silk, and metallic thread,
10 ft. 8¾ in. x 6 ft. 8 in., 19th century
Gift of Fong Chow, 1959 59.190

A Man with a Cat
Jean Dubuffet, French, 1901–1985
Charcoal on paper,
13¼ x 10¼ in., 1943
The Pierre and Maria-Gaetana
Matisse Collection, 2002
2002.456.26

Martha Bartlett with Kitten (detail)
American, 1875–1900
Oil on canvas, 30¼ x 24 in.
Bequest of Edgar William and
Bernice Chrysler Garbisch, 1979
1980.341.11

Cat and Mouse (detail)
Kawanabe Kyōsai, Japanese,
1831–1889
Handscroll; ink and wash on paper,
10⅞ in. x 20 ft. 8 in.
Fletcher Fund, 1937 37.119.1

Harper's July (detail)
Edward Penfield, American,
1866–1925
Commercial lithograph,
9⁹⁄₁₆ x 14¾ in., 1898
Museum Accession, transferred from
the Library, 1957 57.627.9(26)

Tomcat's Turf
Paul Klee, German (b. Switzerland),
1879–1940
Watercolor, gouache, and oil on
gesso on fabric, 8½ x 5⅝ in., 1919
The Berggruen Klee Collection,
1984 1984.315.15

Winter: Cat on a Cushion (detail)
Théophile-Alexandre Steinlen,
French, 1859–1923
Color lithograph, 20 x 24 in., 1909
The Elisha Whittelsey Collection,
The Elisha Whittelsey Fund, 1950
50.616.9

Pet Cat
Kawabata Gyokusho, Japanese,
1842–1913
Ink and color on silk, 14½ x 10⅞ in.
Charles Stewart Smith Collection,
Gift of Mrs. Charles Stewart Smith,
Charles Stewart Smith Jr., and
Howard Caswell Smith, in memory
of Charles Stewart Smith, 1914
14.76.61.87

The Cat That Walked by Himself (detail)
Rudyard Kipling, English,
1865–1936
From *Just So Stories for Little Children*,
London, 1902
Rogers Fund, 1974 1974.617.6

BACK FLAP
Amelia Van Buren
Thomas Eakins, American,
1844–1916
Platinum print, 8¼ x 6⅝ in., ca. 1890
David Hunter McAlpin Fund, 1943
43.87.16

BACK COVER
Little Grey Cat
Elizabeth Norton, American,
1887–1985
Color woodcut, 5⁹⁄₁₆ x 4⅛ in.
Gift of Elizabeth Norton, 1928
28.63.1

Library of Congress Cataloging-in-Publication Data:

Catnip : artful felines from the Metropolitan Museum of Art.
 p. cm.
 ISBN 1-58839-163-9 (MMA : alk. paper) — ISBN 0-8118-5118-4 (Chronicle : alk. paper)
 1. Cats in art. 2. Cats—Quotations, maxims, etc. 3. Art—New York (State)—New York.
 4. Metropolitan Museum of Art (New York, N.Y.) I. Metropolitan Museum of Art (New York, N.Y.)
 N7668.C3C368 2005
 700'.4629752—dc22

 2005003743

Manufactured in China.

Work by Will Barnet © Will Barnet/Licensed by VAGA, New York. Works by Jean Dubuffet and Alberto Giacometti © Artists Rights Society (ARS),
New York/ADAGP, Paris. Works by Paul Klee and László Moholy-Nagy © Artists Rights Society (ARS), New York/VG Bild-Kunst, Bonn. Work by
Dona Nelson courtesy Cheim & Read, New York.

Produced by the Department of Special Publications, The Metropolitan Museum of Art: Robie Rogge, Publishing Manager;
Christine Gardner, Editorial Supervisor; Anna Raff, Designer; Gillian Moran, Production Associate.
All photography by The Metropolitan Museum of Art Photograph Studio unless otherwise noted.

Edited by Carolyn Vaughan

Visit the Museum's Web site: www.metmuseum.org

Distributed in Canada by Raincoast Books
9050 Shaughnessy Street
Vancouver, British Columbia, V6P 6E5

10 9 8 7 6 5 4 3 2 1

Chronicle Books LLC
85 Second Street
San Francisco, California 94105

www.chroniclebooks.com

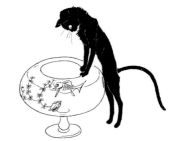

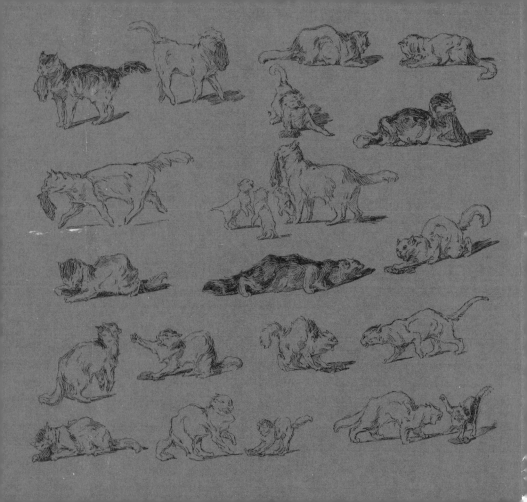